Sit !

Sit!

drawings by
Claudia Schmid
words by
Matt Harvey

Published in 2019 by

Unicorn, an imprint of Unicorn Publishing Group LLP

5 Newburgh Street

London

W1F 7RG

www.unicornpublishing.org

Text © Matt Harvey

Images © Claudia Schmid

ISBN 978-1-912690-44-2

10 9 8 7 6 5 4 3 2 1

Designed by Kath Grimshaw

Printed in the UK for Jellyfish Ltd

CONTENTS

LAPDOG 10

NOT MY DOG 12

DON'T TELL ME 14

SOCIAL SNIFF 16

IN TUNE 18

BIRD SONG (IN TRANSLATION) 20

BUT YOU SAID 22

I'M FINE 24

A DOG CALLED SQUITS 26

OH DOG 28

TEMPORARY STRUCTURE 30

THREE OF A KIND 32

IN RECOGNITION 34

CLUTCH PUPPIES 36

MY DOGGY DON'T GO TO THE TOILET 38

GOOD DOG, SIT 40

BEST IN SHOW 42

CARRY ME 44

DOGNAP 46

WHAT IS THIS LIFE? 48

FRINGE BENEFITS 50

BOATING WITH ARNOLD 52

DOGSWORTH 54

SCENTS AND SENSIBILITY 56

HOWL 58

THE PHILOSOPHER 60

INTRODUCTION

This is a book with dogs in.

Neither Claudia or I are known for our work with dogs. Nevertheless here is a book with at least one dog in every picture, sometimes more. All the words are dog-related, too. We make no apology for this. We are both of us dog owners and dog walkers, and you could argue that this means we really know what we're drawing and writing about. That would be stretching it a bit.

Sometimes Claudia and I meet by chance when walking our dogs. Hers is called Toffle, mine is called Tess. But neither Claudia's pictures nor my poems are necessarily inspired by Tess or Toffle. They are, however, inspired and influenced by the interesting dogs and people we meet on our daily rounds. They are also influenced by people and dogs we don't meet. Personally I think they mostly come out of Claudia's unconscious, which has a lot of creatures in it, some of them humans and dogs. She's a well-populated person and I am lucky to work with her.

Mostly the pictures came first and I added words after due consideration. A couple of times I wrote dog poems and Claudia came up with an image. We hope it's not always obvious which is which. Sometimes the poems give a voice to the dog, sometimes the human, once to a bird singing in a tree. They tend to anthropomorphise the dogs so I've tried to balance this by anthropomorphising the humans too.

If you are a dog owner or dog walker you may recognise yourself somewhere in this book. I hope not, for your sake. Any resemblance between the characters in this book and any real persons or dogs, living or dead, is an achievement.

We hope you enjoy it.
MH

A note about poo:

There are several references to poo. I'm sorry, but we don't apologise for this. Dog walkers know that the problem of poo isn't just a hardy perennial but a daily dilemma. Dogs do it. We deal with it. As ethically as we can. Not all days are equally ethical. No-one is judging anyone here.

LAPDOG

A dog by any other name
Would weigh the same

But we don't judge
And he won't budge

We don't mind if you don't approve
He can't be arsed and I can't move

NOT MY DOG

You're not my dog
> But I could be. I would be, if you'd have me.
> I'd be your very good boy
> I would, I would, I would!

You're not *my dog*
> We could do such things together
> We could we could we could though,
> Couldn't we?

I'm not even a dog person.
> Amazing. That's my favourite. Nor am I!
> I'm a people puppy. A really good boy!
> Am I good boy? I am! I am! I am!
> And I'm yours.

You're not my dog!
> O love the way you say that, it's so funny!
> It's the best fun ever being your dog.

YOU'RE NOT MY DOG
> Love it!
> You're the best owner I've ever had.
> Ever.

DON'T TELL ME

Let me guess
It's something I've done wrong?
Yes?

Did you say sit?
I'm sitting. No?
That isn't it?

Don't tell me
There's something you'd like me to fetch
A stick I didn't see you throw…?
No?

Have I been *bad?* I don't feel bad –
A tad concerned. A little sad

While I work it out
 and think this through
Let's both stay here
 and watch this poo

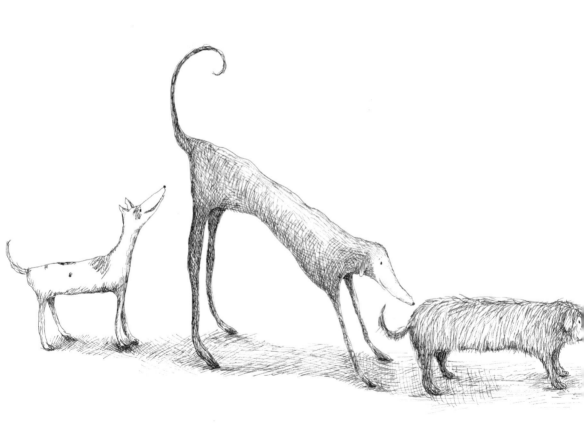

SOCIAL SNIFF

It's great to meet and greet both ends
Of new acquaintances, old friends

To stop and snuffle, scratch and sniff
Absorb the story of the whiff

The sweet specifics of each smell
To savour, then to sniff and tell

IN TUNE

I scratch her neck and tum like this
there's music in our grooming
she's a Bach-loving bitch with perfect pitch
who's never needed tuning

grunts and grumbles, creaks and whistles
yawning sighs, a drawn-out groan
she has such a lovely temperament
and a beautiful, beautiful tone

we nuzzle as we noodle
she's not for cuddles or for kisses
she's my dulcimer dalmadoodle
and I'm her maestro Mrs

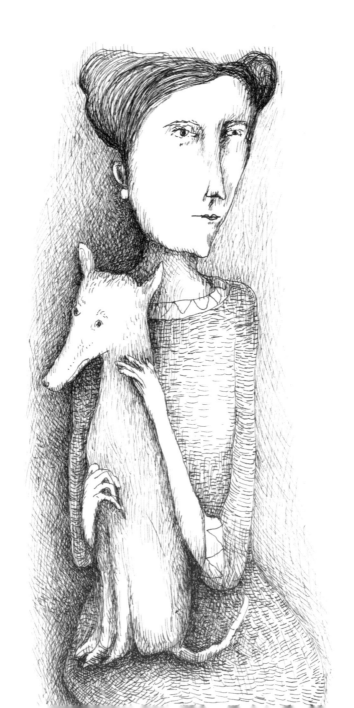

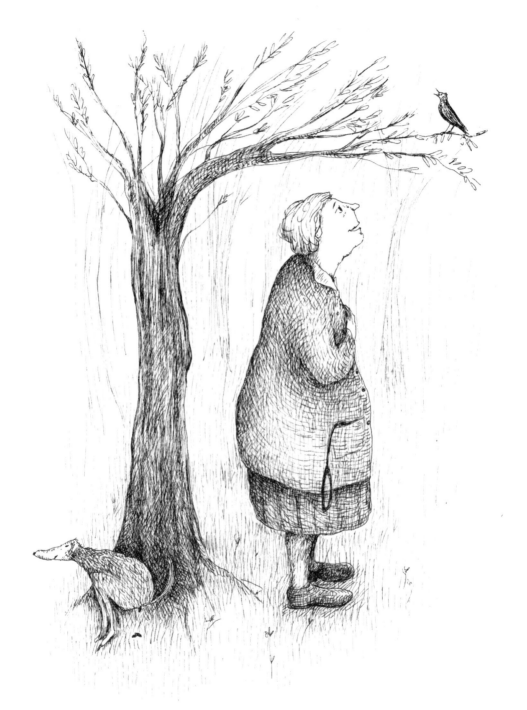

BIRD SONG (IN TRANSLATION)

welcome to these soft green acres
welcome to my woodland home
please feel free to bring your pooch
feel free to roam
 tra la la laa
 tra la la lee
 feel free, feel free

I don't mind you barging through here
with your lolloping hound
I don't mind him doing a poo here
on the soft green ground
 tra la la laa
 tra la la lee
 feel free, feel free

if you choose to leave it lying
and walk away, that's fine by me
but if you choose to bag it, *please*
don't hang it in this tree
 not in the tree
 tra la la laa
 tra la la lee
 not in the tree, not in the tree

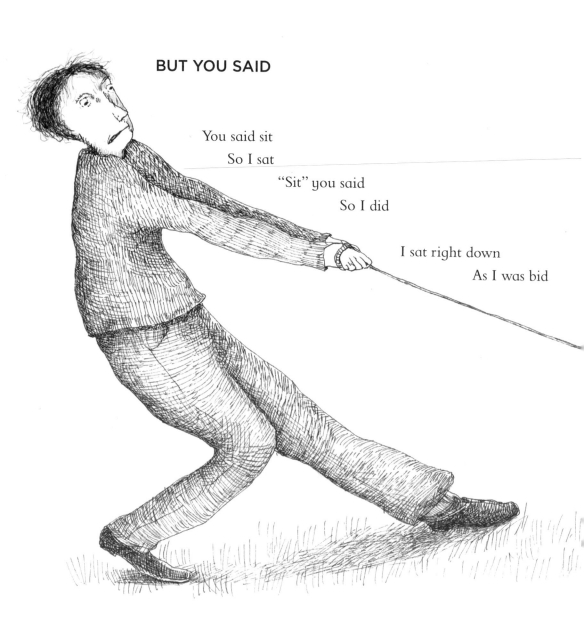

BUT YOU SAID

You said sit
So I sat

"Sit" you said
So I did

I sat right down
As I was bid

Sat down here, upon the floor
I take one order at a time
There isn't room in me for more

I'm a good dog, me

You said sit, so I sat
And I'm happy with that

Why aren't you?

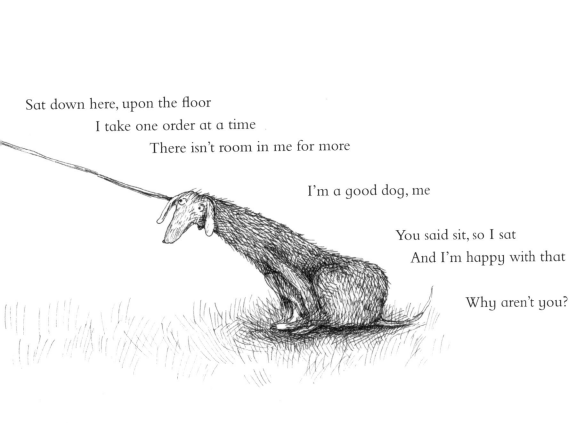

I'M FINE

No, honestly, I'm fine.

Ironically, he's a rescue dog.
Now who needs rescuing?
I know, I know!

Just kidding,
please don't make a fuss.
It's our 'squash time'.
We're building trust.

I'm comfortable,
it doesn't chafe.
What matters is:
that I can breathe
and he feels safe.

A DOG CALLED SQUITS

A dog
called Squits
squats

and grits
its
teeth

waiting for what's
inevitable
emerging underneath

poor Squits'
bot's
sore

for Squits
squats
lots

but that's
why Squits' name
fits

OH DOG

Who loometh above us
Our all-seeing surroundhound

We pray that you fetch
The flung stick of our words and hear
Our barely audible high-pitched prayers
With your awesome, awesome ears.

Lend us the strength to scoop your mess
And come to heel in our distress.
Stay by our side
As we go walkies
On life's designated dogways

Good Dog
That's it
Good Dog
Stay

TEMPORARY STRUCTURE

She likes to come and join us
When we cuddle, when we hug
In our temporary structure
Our kennel of love

She wriggles in between us
And while we snuggle there
She gets extra points for keenness
And very little air

THREE OF A KIND

one little, two little, three fine examples
of a breed at once fragile, expensive and rare
the chap in the middle is Archibald Arnold
his chums either side are called Spares and Repair

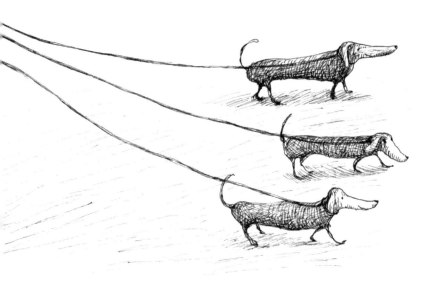

IN RECOGNITION

for poop you've scooped beyond the call of duty
for walks, for sticks you've thrown and sticks I've fetched
for putting up with smells the wrong side of fruity
for all those awkward visits to the vets

for tug-of-war and tummy tickles, for telling me I'm Good
for stern words crossly spoken that I've never understood

for services rendered, for tenderness tendered
for forgiving what I did to your car
being a fine hind-leg-standing example
of whatever-it-is-you-are

I award you the highest honour our breed bestows –
The Order of the Wet Nose

Here's licking at you, kid.

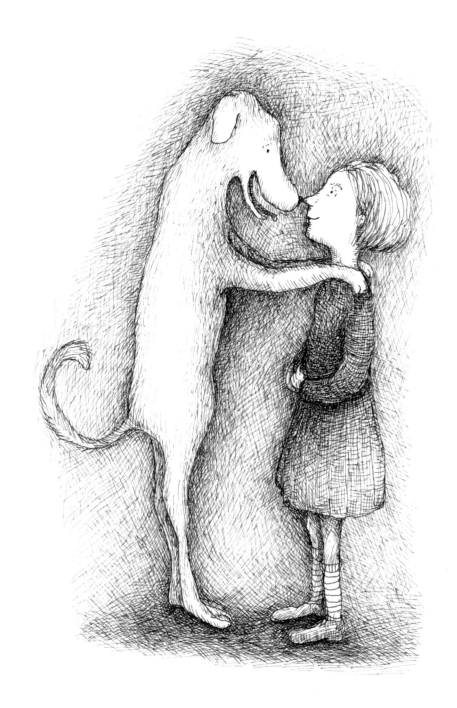

CLUTCH PUPPIES

Look, your one likes my one

clutch puppies, clutch puppies
handy and neat
clutch puppies, clutch puppies
sweet and petite

Can we hold one another's?

It feels so safe and nurturing
When I hold it on my hip

I found mine on a skip

My one's called Dingle

I'm currently single

My friends call me Mindy

It's nice to meet Dingle

And my one likes yours!

Of course, yes of course!

I got mine off the internet

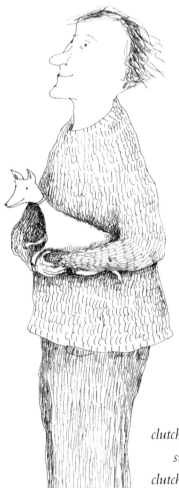

My one's called Eric

Um, my name is Derek

I'm single too

clutch puppies, clutch puppies
sweet and petite
clutch puppies, clutch puppies
make me complete

It's nice to meet you

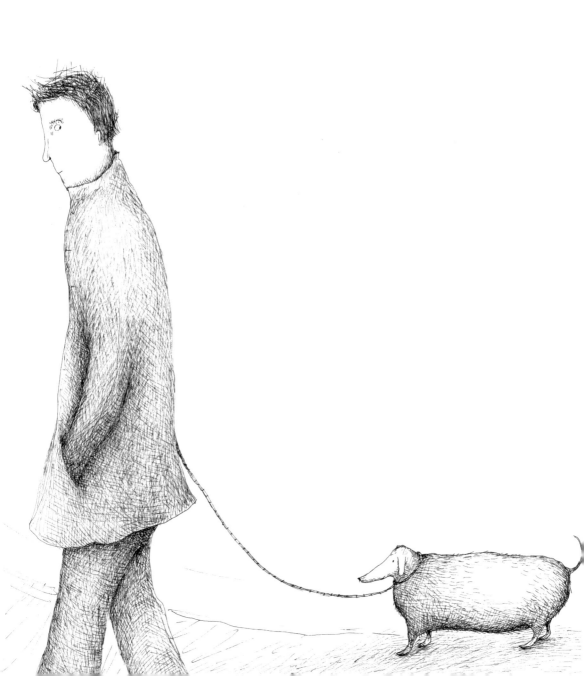

MY DOGGY DON'T GO TO THE TOILET

My doggy don't go to the toilet
He does no. 1's not no. 2's
 Neat little wees
 Beside lampposts and trees
But he's never been known to do poos

My doggy don't go to the toilet
No Big Jobs, nothing to scoop
 He does the odd trickle
 But his output is little
He's never been known to do poop

My doggy don't go to the toilet
But I know, as I walk down the road
 There is no escape
 You can see from his shape
 It fills out his figure
 He only gets bigger
That one day he's going to explode

GOOD DOG, SIT

...ah, so you do understand
with this treat I hold you in the palm of my hand

a moment to savour, a moment to stretch
I can't make you lie down, roll over or fetch

but this savoury snack between finger and thumb
brings you closer by far than you've ever come

to obedience – that's it, good dog, stay!
this is my triumph, the one time you obey

for this wonderful luminous moment of time
you are mine
 you are mine
 you are mine

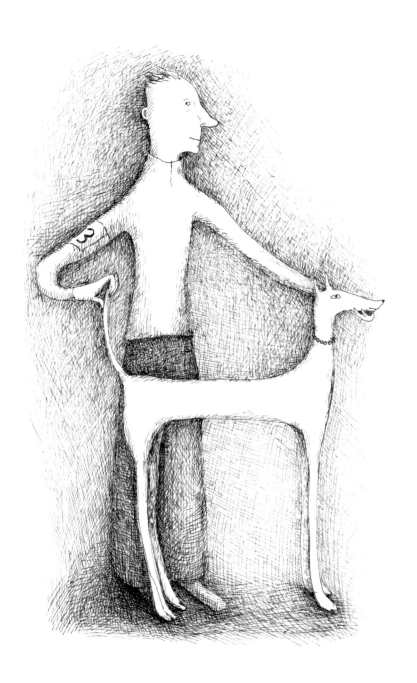

BEST IN SHOW

I'm an ordinary person
it's my dog who's unique
we're both of us keen as mustard
and at our competitive peak

with her pert alert nose
she's a source of great pride
and at all the top shows
I stand tall at her side

I'm more than just her owner
she's more than just a pet
and I always get a boner
when she wins me a rosette

CARRY ME

when I wander down strange avenues
dark corridors of mind
when my emptiness is cavernous
and I'm difficult to find

when I've taken a position
I can't possibly defend
and refuse to show contrition
she will still be my friend

when I'm a wretch she'll fetch me
though I've stumbled way off track
when I'm difficult and tetchy
she will always bring me back

when everything is off-key
all rainbows monochrome
she'll sniff me out and lift me
and carry me back home

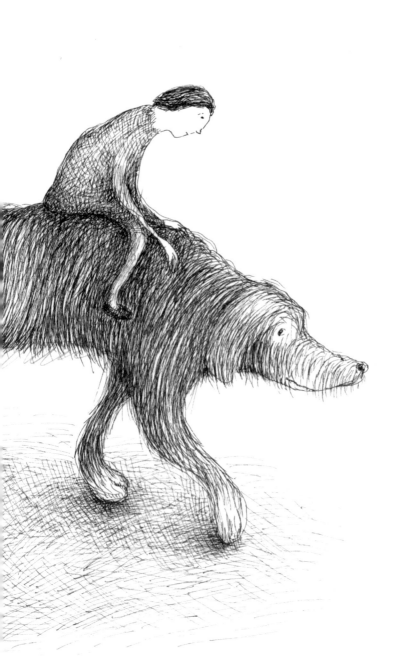

DOGNAP

We're tastefully draped across the settee

His ear on my thigh and his head on my knee

Human and hound
so completely at ease

The sofa's toast,
we're melted cheese

All missions accomplished
and calories burned
The best kind of rest is the rest that's been earned

So cosy and close we're in danger of fusing
One of the known risks of synchronised snoozing

A catnap's okay but a dognap is deeper
It's the slow train to Dreamland – and we're in the Sleeper

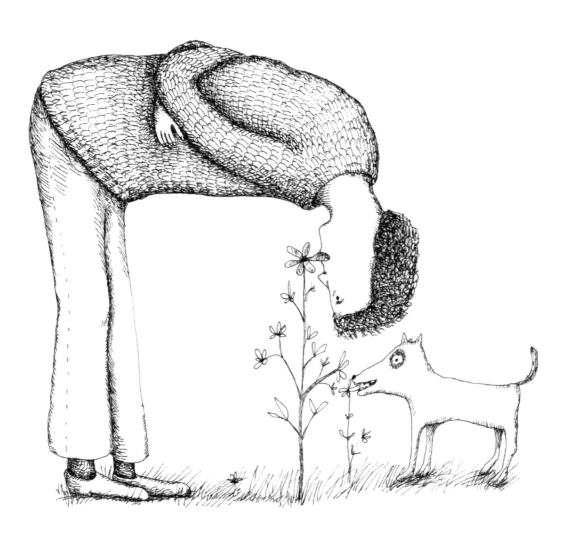

WHAT IS THIS LIFE? *(AFTER W H DAVIES)*

What is this life, what is it, if
We have no time to scratch and sniff

No time to while away an hour
In contemplation of a flower

No time by day or moonlit night
To stoop and twist and lunge and bite

No time to sink our feral teeth
In fragrant petal, glossy leaf

And with our drugged-up wild-eyed hound
To growl and shake it all around

No time to rip and tear and then
To spit it out and start again

A poor life this, and wasted, if
We have no time to scratch and sniff

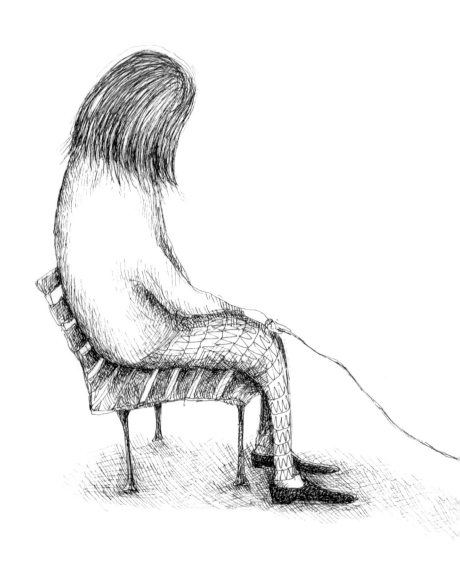

FRINGE BENEFITS

To people enquiring
Why are we so retiring?
It's just down to wiring

Why do we grow our fringes
Those extra nine inches?
To those folk who ask us:
Yes, it's to mask us

We prefer to stay hidden
It's hard to say why
We've not once been bitten
But we're both twice shy

BOATING WITH ARNOLD

Here beside the rustling rushes
Where the water gently washes
Slaps against the boat and sploshes

We find harbour where the hush is
Where a man can fish for fishes
And a dog can wish his wishes

He keeps watch for otters and bubbles and seals
For salmon and kingfishers, adders and eels
He watches for slow worms and glow worms and voles
For badgers and butterflies, magpies and moles

And I thank my lucky flowers
I can while away the hours
With a hound as sound as Arnold

Here beside the rustling rushes
Where the water gently washes
Where a man can fish for fishes
And a dog can wish his wishes

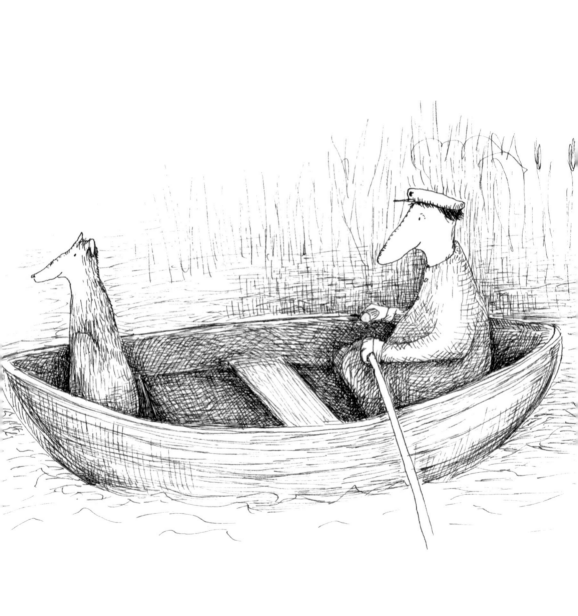

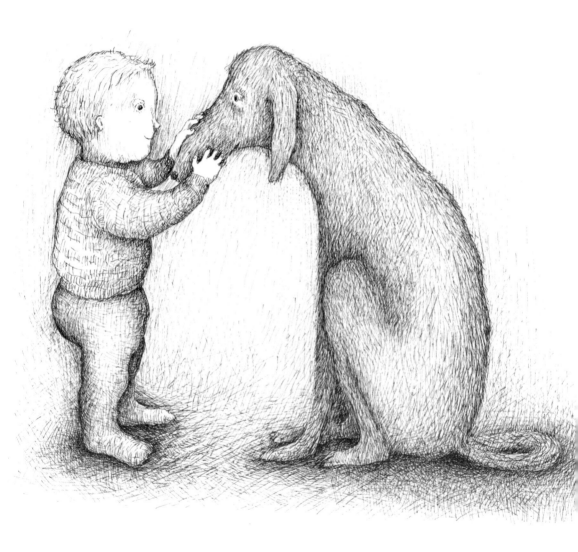

DOGSWORTH

Aww, look at the lovely human pup
A whole dog year till he grows up

And I know without being told
Some instincts must be put on hold

Who would want to snarl or snap
At such a trusting little chap?

Call me a dogsworth
It's more than my job's worth

SCENTS AND SENSIBILITY

I've been clipped I've been snipped
I've been shaved and shampooed
So button your lip
Cos I'm not in the mood

My well-meaning human
Inflicted this grooming
My temper's been shortened
I've been snipped where I oughtn't

I've been slicked I've been spruced
And it's tarnished my image
My tog rating's reduced
My street cred diminished

They gave me a quiff
Doused my natural whiff
With some eau de cologne
Leave my odour alone!

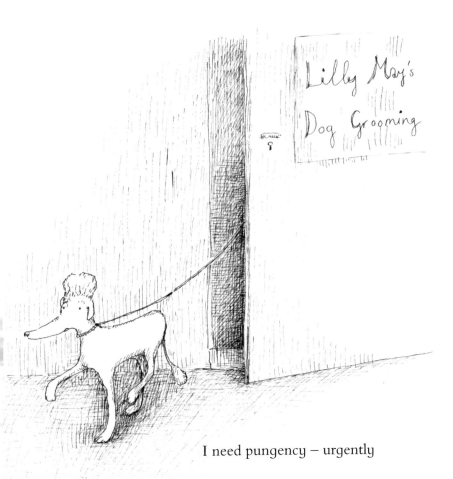

I need pungency – urgently

I need funky bouquet-time
I've almost forgotten
What it is to be canine
I need to sniff bottom

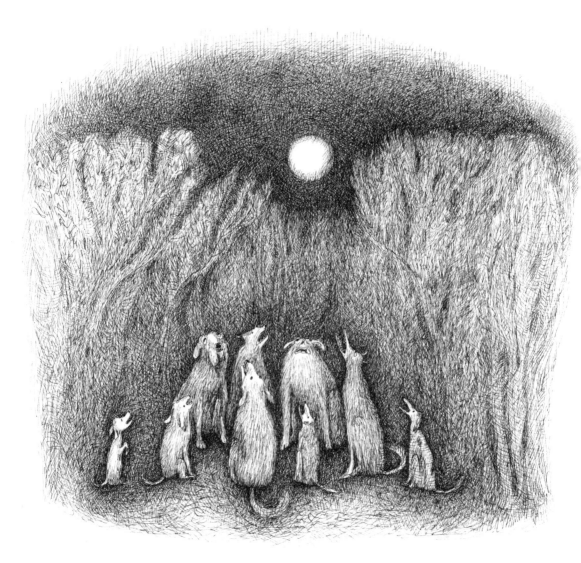

HOWL

We're the Pack Acapella
We meet after dark
When the Moon's full and yellow
On the edge of the park

We're grunters and growlers
Of all shapes and all sizes
We're wailers and howlers
Not here to win prizes

When the Moon becomes full
There's a tug, there's a pull
And we give it our all
As we honour the call

That our ancestors
 answered to

When the Moon's at its zenith
We howl our two penn'orth
Our deep doggy wishes
And though some have issues

With personal fitness
The Moon is our witness
That for all the rich dinners
We've still got it in us

We may have been tamed
Inappropriately named
But for now we forget
That we're somebody's pet

We are wolves

THE PHILOSOPHER

Here's where I sit and take time to reflect
On cats I've chased, bones buried, sticks I've fetched

Oh the things I've done, the times I've had
Sometimes I've been a Good Boy, sometimes Bad

But there's more to life than cats and bones and sticks:
Like snacks, smells, sleeps, the teaching of new tricks

(That I pretended not to understand)
The time when, curious, I bit the hand

That fed me – not from anger, just to see
What it would taste like (slightly salty)

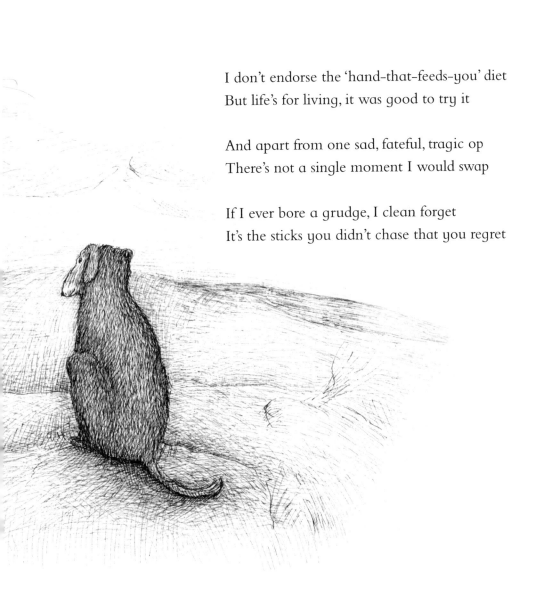

I don't endorse the 'hand-that-feeds-you' diet
But life's for living, it was good to try it

And apart from one sad, fateful, tragic op
There's not a single moment I would swap

If I ever bore a grudge, I clean forget
It's the sticks you didn't chase that you regret

CLAUDIA SCHMID

In between walks with Toffle, Claudia Schmid works as an illustrator, artist and maker of *Dutzi* soft toys. Her drawings of strange creatures in both human and animal form are well known locally and further afield. She has collaborated with Matt on *Mindless Body, Spineless Mind* and illustrates his regular columns for *Resurgence* magazine. She lives with her daughter Felice in Totnes, where she has lived longer than anywhere else before.

www.claudiaschmid.co.uk

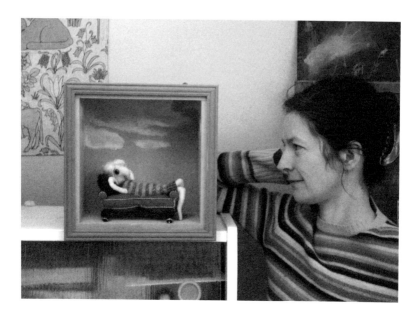

MATT HARVEY

Poet, lyricist, dog-walker and columnist, Matt Harvey writes about all sorts of things, performs up and down the country and is often heard on the radio. His books include *The Hole in the Sum of my Parts*, *Mindless Body, Spineless Mind* (also with Claudia) and *The Element in the Room*. His dog, Tess, often sits beside him as he writes. They say, "Be the person your dog thinks you are," but Tess looks at him reproachfully, her eyes full of questions.

www.mattharvey.co.uk

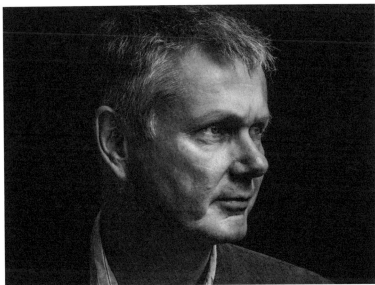

Photograph by Benjamin J Borley